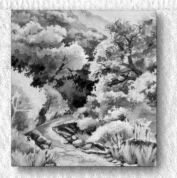

Color Made Easy

Watercolor is known as a luminous and vibrant medium, but without a basic understanding of color, beginning artists often find it challenging to bring out these desired qualities. This guide will arm you with everything you need to know to create fresh and lively artwork right away. You'll find simple illustrations and explanations that show you everything from the emotional aspects of color to mixing techniques and pigment properties. And you'll also find engaging, color-focused projects that give insight to the planning and execution of colorfully dynamic paintings.

CONTENTS

TOOLS & MATERIALS

Watercolor has gained in popularity as more people have discovered its practical advantages and fresh vitality. There are no thinners or additives with watercolor, and cleanup is fast and simple. And the vibrant pigments and fluid washes make painting an expressive and spontaneous experience unmatched by other media. As you shop for your art supplies, always try to purchase the best quality you can afford; higher-quality materials are easier to use and produce more vibrant and longer-lasting results.

CHOOSING PAINTS

Watercolor paints come in three forms: cakes (dry blocks of pigment), pans (semi-moist wells of pigment), and tubes (moist paint that can be squeezed easily onto a palette). Cakes and pans are activated by stroking over them with water, and tube watercolors mix readily with water, making them the more convenient choice.

It's a good idea to buy artist-grade paints rather than student grade. Artist-grade colors are made with better pigments and less filler, so the colors are more intense. As you'll discover in this book, you don't need dozens of colors to start painting—you can mix many colors from just a few tubes of paint. However, you do need to have a warm and a cool version of each primary color (red, yellow, and blue), plus it's a good idea to include a few browns and greens. In this book, each project will inform you of the exact colors needed to complete the featured painting.

PICKING A PALETTE

Purchase a palette with wells large enough to accommodate your largest brush and plenty of divided areas in which to mix colors. The palette pictured at right is white plastic with a lid to seal in moisture between sessions. These large palettes are best to use in the studio, whereas smaller palettes featuring just a few colors are more convenient for using outdoors.

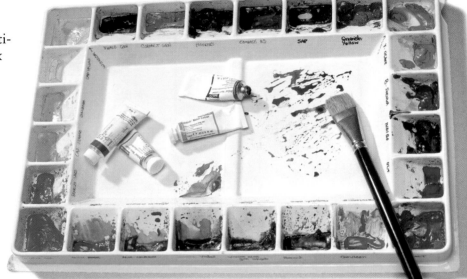

LABELING YOUR PALETTE Once you've decided on a selection of colors to have in your permanent palette, it's a good idea to mark the paint colors on the outside and inside walls of the palette with indelible ink so you don't refill a well with the wrong color.

MASKING FLUID Many watercolorists use masking fluid, or liquid frisket, which is a latex-based substance that can be "painted" over areas that are meant to remain white. When dry, the mask repels paint, so you can paint over it without covering the white support underneath. When the paint is dry, gently rub off the mask with your finger to reveal perfectly shaped areas of pure white. Masking fluid is available in white and with tints so you can better see it against white paper.

SPONGES You can apply paint with sea silk, sea wool, and yellow natural sponges to create interesting textural effects. Just dip the sponge in paint and dab it onto the watercolor paper. For a larger texture, tear or cut a large sponge apart to expose more of its surface.

WATER CONTAINERS It's a good idea to have two water jars ready to use: one for washing brushes and the other to hold clean water for diluting your paints. If you choose to use only one jar, make it a big one and change your water often.

SPRAY BOTTLE Having a spray bottle on hand is useful for re-wetting your colors when they start to dry and for adding extra water to the mixes on your palette. You can also spray water directly on your damp painting to create some lovely effects!

MASKING EDGES

You'll want to use artist's tape to mask the edges of your painting area. This type of tape is less sticky and doesn't leave a residue the way ordinary masking tape does. Once you've finished the painting, gently remove the tape by pulling up and away from the center of your paper. This movement will reduce the chance of tearing paper fibers along the edge of your painting. Removing the tape will reveal a clean, white edge that will help you better judge your colors and give you an idea of what the painting will look like matted.

BUYING BRUSHES

Watercolor brushes are categorized by hair type, shape, and size. Hair types are either natural or synthetic: Natural-hair brushes are made from the hair of a variety of different animals, whereas synthetic-hair brushes are made from nylon and other non-animal materials that mimic the qualities of natural hair. Often watercolorists prefer natural-hair brushes, as they were once considered more absorbent and resilient than their synthetic counterparts. However, the rarity and expense of natural hair has prompted the recent development of excellent-quality synthetic brushes.

Watercolor brushes come in several shapes, but you'll need only round and flat to complete the projects in this book. Round brushes have bristles that taper to a point, allowing them to hold a good deal of water as well as produce fine lines. Flat brushes have bristles of the same size, which is great for creating thick strokes and "drawing" with the edge or corner of the brush.

It's a good idea to start with a few sizes of each brush shape, as shown at right. Round brushes often are sized by a numbering system determined by the manufacturer of that particular brand, but you can still compare sizes between brands by measuring the diameter of the metal cylinder at the base of the bristles. Flat brushes are sized by the width of the bristle base.

CHECKING OUT PAPER TEXTURES

Watercolor papers can be divided into three different textures: Hot-pressed paper has a smooth surface; cold-pressed paper has a medium texture; and rough paper has the most grainy, tactile surface. The smooth finish of hot-pressed paper is useful for laying down washes because the paint will flow easily over the paper. The slight texture, or "tooth," of cold-pressed paper holds the paint well but does not interfere with detail, making it the most popular watercolor paper texture. The distinct texture of rough paper makes the paint settle into the surface, creating a slightly mottled effect. Each manufacturer's paper has its own characteristics, so be sure to experiment on various types and brands until you find your favorites.

EXPLORING PAPER WEIGHTS

Watercolor paper comes in different weights, designated in pounds. The higher the number, the heavier the paper and the less likely it is to warp when you apply water. 140-lb is a very popular weight, but it won't hold many layers of watercolor. When planning to use several glazes, use 300-lb paper; the paint will seem to sink in and take on a velvety appearance.

WATERCOLOR PAPER These three different sheets show how the paint looks on hot-press, cold-press, and rough, textured paper.

FLAT This brush, either 1- or 1/2-inch wide, is perfect for applying flat and gradated washes and backgrounds.

ROUND These are very versatile brushes. Start with 1/4-, 3/16-, and 5/32-inch rounds.

HAKE This brush is great for laying in backgrounds on very large areas.

TOOTHBRUSH Save your old toothbrushes for spattering on specks of color when you want a bit of texture.

PAPER TOWELS Toweling and facial tissue are good tools for cleaning the wells of your palette, adding textures to a painting, and wiping off an "oops!"

COLOR BASICS

Understanding how colors relate and interact is crucial for creating successful watercolor paintings. This page offers the perfect starting point, as it allows you to familiarize yourself with a number of terms and concepts that will help you understand the lessons and demonstrations in the book.

COLOR TERMS

Before you start painting, it's helpful to become familiar with some color terms. The three primary colors (red, yellow, and blue) are the only colors that can't be created by mixing other colors together; nearly any other color can be mixed from some combination of the three primaries. When you mix two primaries in equal parts, you create a secondary color (purple, green, orange). In addition, "hue" means the color itself, such as red or green; "intensity" or "chroma" refer to the strength of a color, from its pure state (right out of the tube) to one that is grayed or diluted; and "value" refers to the relative lightness or darkness of a color (or of black).

COLOR AND TEMPERATURE

Colors are often referred to as either "warm" or "cool," and artists use these "temperatures" to convey mood, season, time of day, and even depth. Colors on the red side of the wheel (yellows, reds, oranges) are warm colors; they evoke a sense of energy and excitement and are associated with summer, afternoons, and sunsets. The colors on the blue side of the wheel (greens, blues, purples) are cool colors; they are generally calm and soothing and are associated with morning, evening, and winter—all times of quietude. Moreover, warm colors appear to advance, so they are often used for foregrounds and areas of interest; cool colors appear to recede, so they're best used for painting distant objects or backgrounds. For more on color temperature and its associations, see pages 8 and 9.

MIXING WARM AND COOL COLORS

Although reds, oranges, and yellows are generally considered warm and blues, greens, and purples are considered cool, there are variations in "temperature" within each hue. For example, a red that contains more yellow, such as cadmium red, appears warmer than a red with more blue, such as alizarin crimson. Most artists choose both a warm and a cool version of each primary color for their palette to provide a wider range of mixing possibilities.

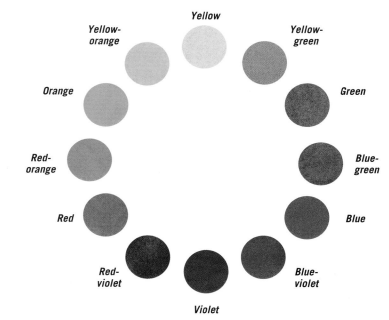

USING A COLOR WHEEL A color wheel provides a visual reference for studying the relationships among colors. Complementary colors are any two colors that lie directly across from each other on the color wheel, such as red and green, purple and yellow, or blue and orange. Analogous colors are any three colors that are adjacent on the wheel. When used together in a painting, they create a sense of harmony due to their similarity. For more on color relationships, see page 6.

CREATING VALUES IN WATERCOLOR

Variations in value create the illusion of depth and form in a painting. With opaque media, such as oil paint, you lighten the value of colors by adding white, and you often begin painting with the darks, building up to the lights as you progress. But with watercolor, you lighten values by adding more water (the lightest value being the white of the paper), and you usually start with light values and build up your darks with additional applications, as illustrated below.

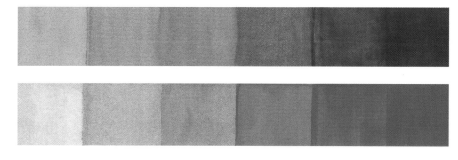

GRAYING WITH COMPLEMENTS

When complementary colors (see color wheel caption above) are placed near each other, they create high energy and dramatic contrast. But when mixed together, they produce an array of stunning neutrals. These muted grays and browns are more like colors found in nature than most pure watercolor paints are. The blacks produced from mixing complements are also generally richer and more complex than flat blacks straight from a tube or pan.

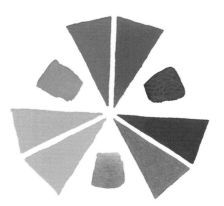

MIXING VIVID SECONDARIES
For vibrant secondary colors, mix two primaries that have the same "temperature": two cools or two warms.

MIXING MUTED SECONDARIES
To create more neutral, subdued secondary colors, mix two primaries of opposite "temperatures": a warm with a cool.

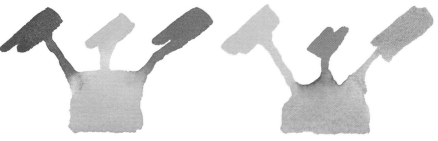

MIXING THE THREE PRIMARIES A variety of neutrals results from mixing the primaries. These examples show the different mixes created by warm and cool combinations. The swatch above right shows how ultramarine blue, lemon yellow, and alizarin crimson combine to create a warm tan; at left, notice how cerulean blue used instead of ultramarine blue in the mix creates a cooler brown.

COLOR-MIXING TECHNIQUES

The simplest way to mix colors is to combine washes in the wells of your palette; however, this can produce flat, lifeless colors. Mixing colors directly on the paper results in more interesting blends and effects. From layering washes to allowing the colors to flow into each other, the techniques below offer exciting ways to apply and combine your pigments.

GLAZING AND LAYERING COLOR

The transparency of watercolor makes it difficult to achieve dark colors with just one application because the white of the paper always shows through to some degree. To build up darker colors, watercolorists use a technique called "glazing," which is painting a thin layer of paint over an existing (dry) color. In addition to being used to achieve a darker value, a glaze can be applied to mix colors visually on paper. Some colors are more transparent than others are, so experiment with your palette to determine the effects various glazes produce.

LAYERING TO DARKEN COLOR Layering color is the most effective way to build up darks in watercolor. It's very important to let the first layer dry before painting over it, so as not to disturb the color below.

LAYERING TO MIX COLORS Layering can also be used to mix colors. When you paint a new color over an existing color, the two mix visually. You can alter the color underneath by painting over it, but you can't completely mask it with the new color.

LAYERING WITH MORE OPAQUE COLOR Most watercolors are quite transparent, but the more opaque colors, such as cerulean blue, lemon yellow, and yellow ochre, all can be used to lighten the value of a color underneath.

LAYERING LIGHT OVER DARK When you layer a lighter color over a darker one, the lighter color usually won't significantly change the color beneath it. But when the lighter color is more opaque, you can achieve dramatic results.

MIXING WITH WET INTO WET

This technique encourages paints to blend on their own; the colors will run and bleed, creating soft edges and lively patterns. First lay the paper flat and use a large flat brush to apply generous amounts of water to the paper's surface. When the water settles into the sheet, apply a second layer of water. Once the paper has an even, satin sheen with no drying areas or pools of water, apply diluted paint.

CHARGING IN COLOR

A few of the projects in this book call for charging in color. For this color-mixing technique, simply stroke a strong wash into an already-applied wash that is still wet. The existing wash on the paper will pull in color from your brush, creating interesting blends with unexpected edges.

GRANULATION

On occasion, color mixes will separate on paper, producing a speckled look when they dry. Granulation, or the separation of the pigments from water, occurs when coarser pigments settle into the depressions of the paper. Ultramarine blue and earthy colors, such as raw umber, are more likely to cause granulation than others are. Some watercolorists deliberately use these granular colors to create texture—or just to add *pizzazz* to their paintings.

GRANULATION EFFECT This is an example of a granulated effect (the technical term is "precipitation") you get by layering watercolors. The effect is more apparent with some colors than it is with others. Here yellow ochre, cerulean blue, and alizarin crimson have been layered over ultramarine blue.

COLOR SCHEMES

Color schemes are combinations of colors that create an appealing visual dynamic. There are many types of color schemes, several of which are shown on these two pages. Some schemes create contrast and excitement; others create harmony and peace. Keep in mind that each scheme affects the subject of a painting differently, so it's important to assess your goals and select a color scheme before you begin painting. Also, note that color schemes are a general way of categorizing the dominant colors used in a painting; not every single color used in a painting has to be straight from the selected color scheme.

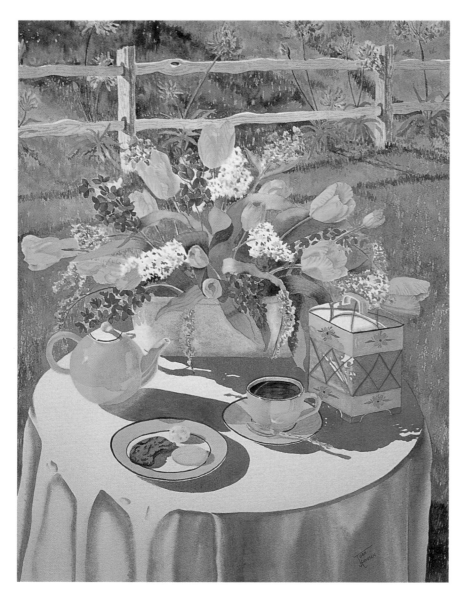

◄ COMPLEMENTARY COLOR SCHEME The dominant colors in this painting are yellow-orange and blue-violet, which lie opposite each other on the color wheel. The artist has placed these two colors adjacent to one another throughout the still life, which makes the complements appear especially vibrant. (To re-create this painting step by step, see page 12.)

► SPLIT-COMPLEMENTARY COLOR SCHEME This scheme combines a color (in this case, blue) with two colors adjacent to its complement (yellow-orange and red-orange). The scheme retains a hint of the vibrant interplay of a complementary scheme but includes more variety in hue. (To re-create this painting step by step, see page 14.)

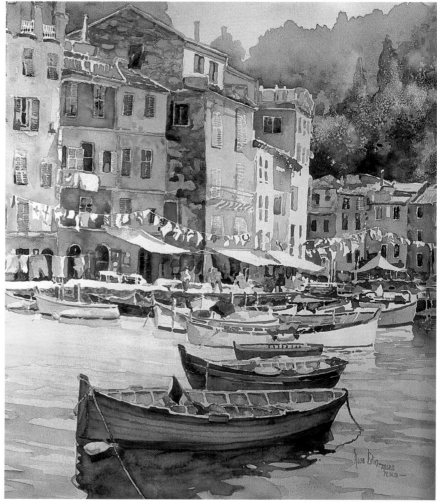

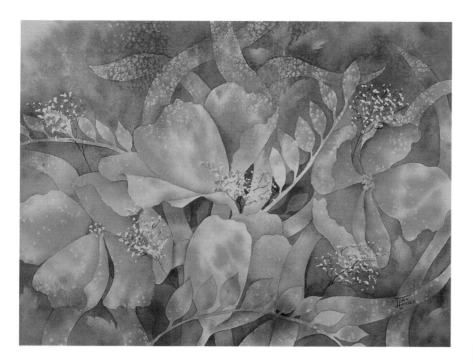

◄ TETRADIC COLOR SCHEME
This color scheme involves two pairs of complements (such as red-orange/green and yellow-orange/blue-violet), creating a square or rectangle within the color wheel. The complements vibrate against one another and produce a colorful scene full of life. Notice how this dynamic makes the flowers seem to "pop" from the background.

► TRIADIC COLOR SCHEME
This scheme combines three colors that are evenly spaced apart on the color wheel. Using all three of these colors in equal weight can overwhelm the viewer, so it's best to allow one color to be more prominent (such as the green in this painting).

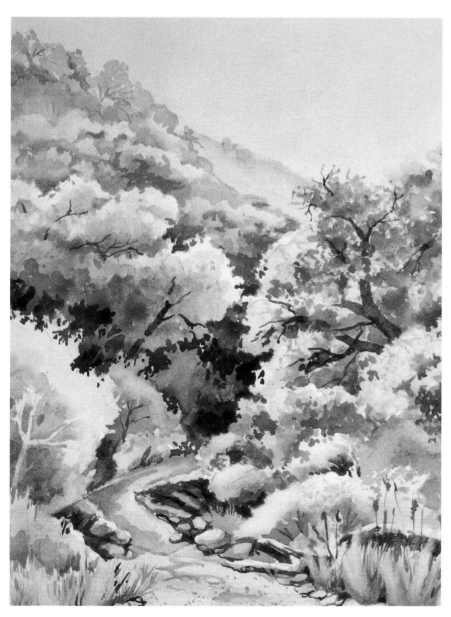

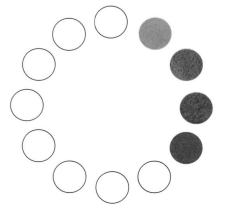

◄ ANALOGOUS COLOR SCHEME
This harmonious scheme combines colors that are adjacent to one another on the color wheel, so they are all similar in hue. In this particular instance, the artist has muted (or grayed) all of the colors to communicate the quiet and solitude of diffused, early morning light.

COLOR PSYCHOLOGY

The power of color is revealed in expressions such as "feeling blue," "seeing red," and "green with envy." Understanding color and how it affects human emotions is one of the keys to creating successful watercolor paintings because the colors you select will affect the viewers' perceptions and elicit an emotional response. In other words, your choice of colors will determine whether your paintings evoke feelings of warmth and happiness, calm and intimacy, or drama and chaos. But the influences of color don't stop at human emotion—color can communicate much more in a painting, including seasons or the time of day. Use the information on the following two pages to build on your instinctual understanding of color.

SETTING THE MOOD WITH LIGHT AND COLOR

As an artist, you can use your artistic license to manipulate what you see to suit whatever mood strikes you and to take advantage of all the colors in your palette. In both paintings below, the artist focused on the dramatic element of the play of light and shadow on the path. But the feeling evoked by each is distinctly different. On the left, warm tones make the scene feel lively and active; on the right, an array of cool colors create a serene and peaceful setting.

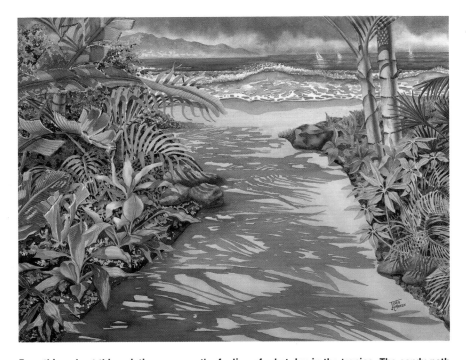

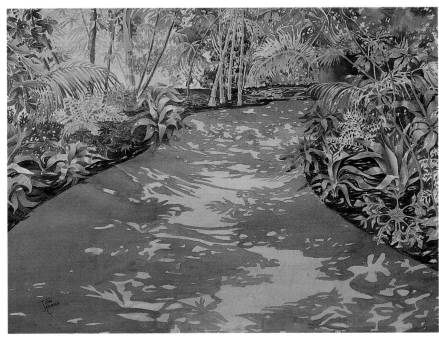

Everything about this painting conveys the feeling of a hot day in the tropics. The sandy path is lit with warm yellows and oranges, and the cast shadows are deeper values of the same tones. The artist even used warm greens and reds in the foliage and flowers along the pathway. The result is an invigorating floral scene that teems with energy and vitality.

In contrast to the painting on the left, this similar subject sets quite the opposite mood. Now the cool shadows appear languid instead of lively, and the light on the pathway seems soothing and calm. The same purples are echoed in the plant life, and even the green foliage has cool blue overtones—here you can almost feel the cool moisture in the air.

SUGGESTING TIME OF DAY

In addition to a general mood and feel of a painting, color can help an artist illustrate a particular time during the day. For example, warm colors like red, orange, and yellow are representative of the higher temperatures of the afternoon. On the other hand, cool colors like blue and purple are associated with morning and evening, when the air is cooler and times are quieter. Consider these associations when choosing the dominant colors of your painting, as the colors will influence the atmosphere and setting of your painting.

◄ The warm colors and distinct shadows of the scene at left suggest the afternoon. At this time of day, the sun is strong and at a slight angle, creating bright highlights and dramatic cast shadows.

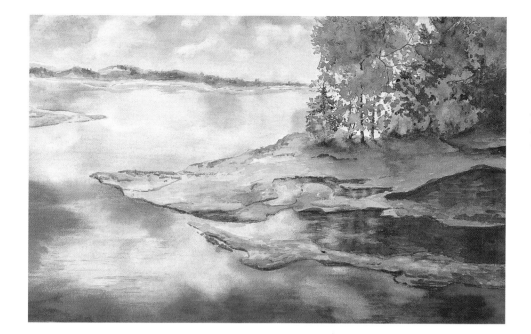

REVEALING SEASONS WITH COLOR

Just as you can use color temperature to suggest the time of day, you can also use color to suggest a time of year. See how adjusting your color palette can invoke the freshness of spring, the fullness of summer, the rich warmth of autumn, or the crisp chill of winter.

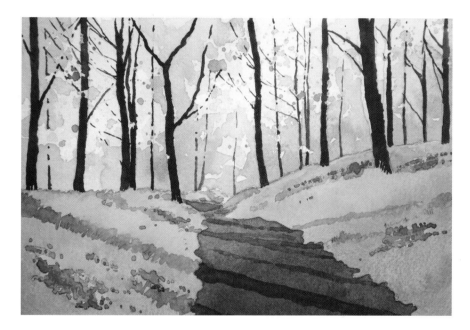

Spring is a time of new growth, calling for the use of bright yellow-greens and vibrant blossom hues. In general, remember to keep your colors unmuddied, fresh, and light.

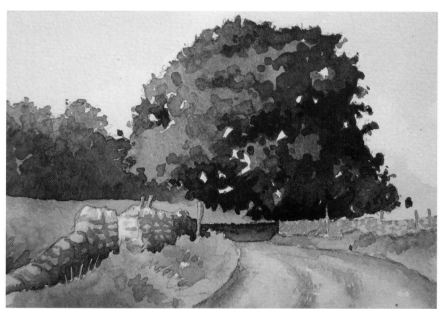

Make summer palpable by saturating your painting with heavy greens. Lean both warm and cool within your trees to give them fullness and depth, and keep the sky a sunny blue.

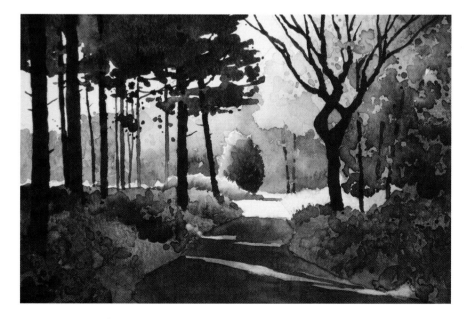

Reflect the deepening colors of autumn by warming the scene with oranges, reds, browns, and dark greens. Strong shadows will also hint at the shortening length of days.

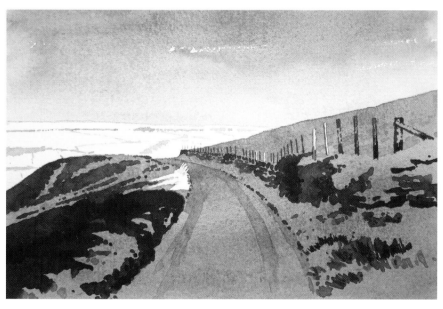

To suggest the cold of winter, dominate the scene with cool blue and purple hues. But remember to throw in a bit of warmth for contrast, such as the bits of yellow ground above.

BUILDING UP COLOR WITH GLAZES

with Geri Medway

Watercolors have a beautiful transparent quality that can make them appear to glow. You can create a very translucent look with one wash of color, or you can layer them to increase intensity.

GLAZING FOR "GLOW"

Glazing with watercolor is like layering sheets of colored cellophane one over another. Because a watercolor glaze is so thin, light travels through the layers of paint, bounces off the white paper, and reflects back at the viewer's eye. Glazing created the luscious blends of color you see in the grapes on the opposite page.

APPLYING GLAZES

To build up the colors gradually, mix the first glaze with a lot of water and each additional glaze with a little less water and more pigment. Each glaze is still translucent, though, so when you choose your first glaze color, keep in mind that it will show through all the colors glazed over it. For example, to achieve the dark purple of these grapes, start with a layer of light pink, knowing that it will combine with subsequent blue layers and appear purple. The most important rule of glazing is that the first layer must be absolutely dry before the second glaze is applied. Otherwise, the new layer might lift some underlying paint, making the colors muddy.

1 I use one of my own photos of concord grapes for reference. This subject requires a more complete drawing than most other subjects. I need to know the exact location of each overlapping shape in order to paint the grapes realistically.

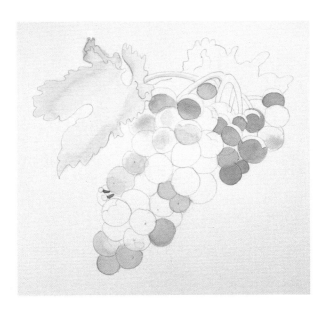

2 I apply my first glazes using cadmium yellow light for the underglow on the leaves and permanent rose for the very light pink highlights on select grapes.

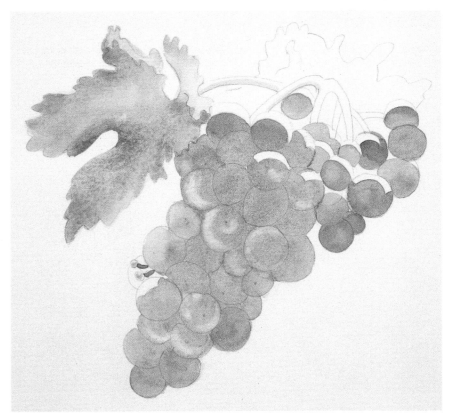

3 After the first glaze thoroughly dries, I add a layer of ultramarine blue to the grapes. Notice how vibrant the color looks where I apply the blue over the glaze of permanent rose. Then, to create the special green color of the leaf, I glaze over some of the areas of cadmium yellow light with a layer of cerulean blue.

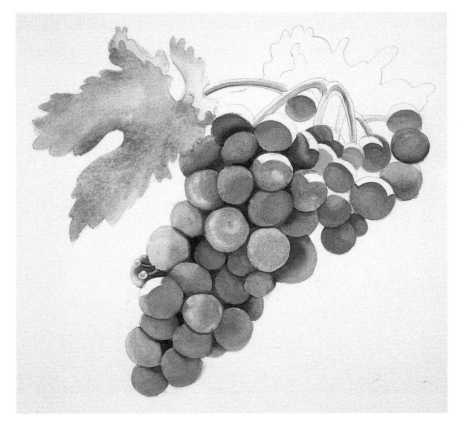

4 To define the grapes, I use the point of my brush to outline and paint the shadows between them with a mixture of indigo and ultramarine blue. I immediately go over the blues with a damp brush to soften the edges. I also find that I have to darken the rose tones.

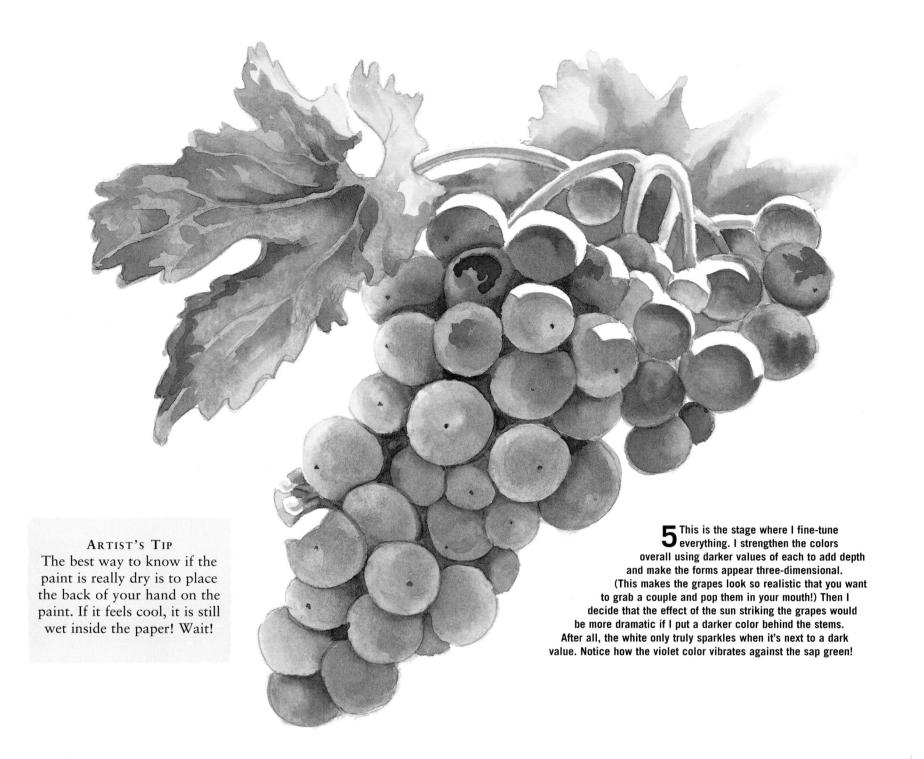

5 This is the stage where I fine-tune everything. I strengthen the colors overall using darker values of each to add depth and make the forms appear three-dimensional. (This makes the grapes look so realistic that you want to grab a couple and pop them in your mouth!) Then I decide that the effect of the sun striking the grapes would be more dramatic if I put a darker color behind the stems. After all, the white only truly sparkles when it's next to a dark value. Notice how the violet color vibrates against the sap green!

PAINTING PERFECT GRAPES AND LEAVES

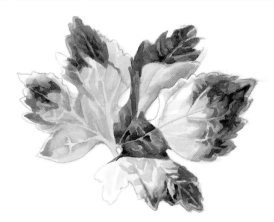

GLAZING GRAPES To paint realistic-looking grapes, begin with an "underglow" of permanent rose, reserving the white highlight. When this layer is dry, I glaze over it with ultramarine blue, adding a little more water to the mix where the color is lighter. Then I add more ultramarine blue to deepen the shadows on and between the grapes.

LAYERING COLORS To capture the sunlight showing through the leaf, I apply cadmium yellow light to the sunny areas. When dry, I add a glaze of cerulean blue to create the green areas. Before this dries, I add orange mixed with a touch of red to the still-wet tip of the leaf.

ACCENTUATING WITH CONTRASTS Notice how contrasting light and dark values not only makes a dramatic statement but also adds a lot of depth and form to the leaf. For the dark green areas, I add a little phthalo blue to a sap green glaze. To create the darkest green value, I add a touch of alizarin crimson to the blue and green mix.

USING A COMPLEMENTARY SCHEME

with Joan Hansen

This still life reference showcases two dominant sets of colors: the golden yellow hues of the tulips and tea set, and the blue-violet hues of the smaller flowers and table shadows. On the color wheel, these hues are opposite each other, providing the opportunity to create a lively floral scene with a vibrant complementary color scheme.

SETTING UP A STILL LIFE

After deciding on a vertical format for my painting, I test out different compositions. I rearrange the objects and take several photos from different angles and with different light sources. I overlap some objects, so the composition is cohesive and shows depth, and I use diagonal lines to lead the eye and create movement. For this afternoon tea painting, I finally settled on a vertical, asymmetrical design. (See reference photo at right.)

1 Using a wet-into-wet technique, I start painting the tulips with a light value of a cool cadmium yellow pale. When the yellow is dry, I use cerulean blue to paint the basic shapes of the light blue flowers, and I use ultramarine blue for the darker blossoms. When the first layer is dry, I add a darker value of manganese blue to the light flowers to give them form, and I add darker values of ultramarine blue to the dark flowers.

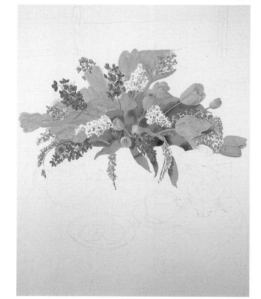

2 After assessing the overall composition of the bouquet, I add a few more tulips and dark blue flowers; then I decide that some white flowers would add light to the center. I leave the white of the paper for the lightest value and paint shadows with middle and slightly darker values of cerulean blue. I stroke yellow ochre in the tulips to show the petal separations and cast shadows, softening the separations with clear water and leaving the shadow edges crisp. When the flowers are dry, I paint the leaves and stems with different values of blue-greens and yellow-greens.

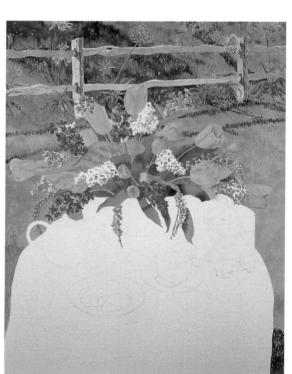

3 Next I paint the background flowers with cerulean blue, grayed with a little mineral violet. When they are dry, I paint the split-rail fence with a mix of mineral violet, burnt umber, and cerulean blue. For the grass, I apply yellow-green, lift off a little color with a dry facial tissue, and then paint back into it with a darker green. When dry, I drybrush across the grass for more texture.

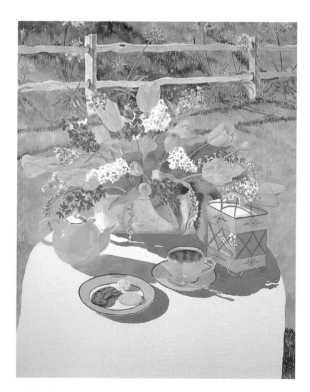

4 I paint the flower container a light blue-gray; then I apply masking fluid (see page 25) on the highlighted areas of the china. I paint the shadow wet-into-wet with a gray-blue, following the contour of the knob, and add the darker cast shadow when dry. I glaze the china pieces with cadmium yellow pale, paint the shadow with a mix of yellow ochre and cadmium yellow pale, and then blend the edges.

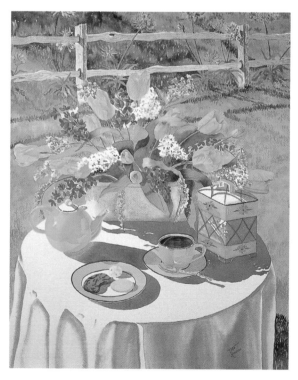

5 For the cast shadows, I use a gray-blue mix of cerulean blue, ultramarine blue, and a little burnt umber, and then apply it to dry paper. Then I rinse my brush and charge in yellow ochre around the base of the teapot, blending lightly between colors. I paint the bottom portion of the tablecloth using the shadow colors, softening some edges and leaving some crisp.

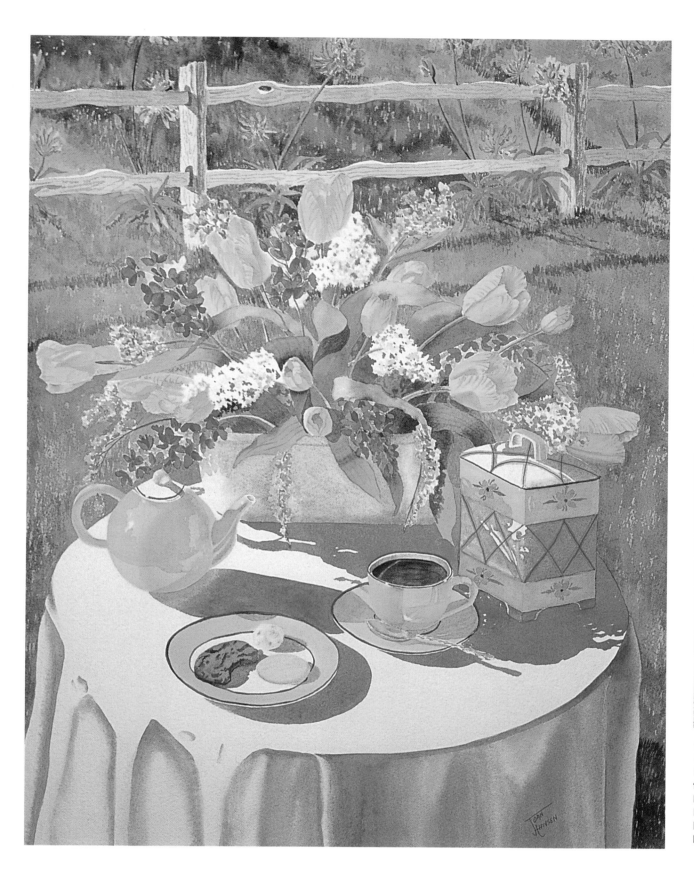

6 Now I step back and look at the painting with a fresh eye. The value of the grass is too close to the value of the yellow tulips, so I deepen the color in the lawn area by dry-brushing over it with another layer of yellow-green. Then, on the sides of the table that are farthest from the sunlight, I work in a few more of the shadow tones I used on the top of the table. This helps integrate the top and sides a little better, so the tablecloth looks like one piece of fabric.

> ### ARTIST'S TIP
> To make a light-weight watercolor board for traveling or painting outdoors, cut a piece of heavy cardboard a little larger than your paper, and cover it with plastic wrap.

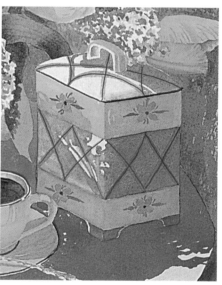

COOKIE JAR Most of the cookie jar is in shadow, but there are sparkles of sunlight. I begin by masking off the highlights. I paint from light to dark, starting with the yellow bands and then painting the blue shadows, letting the colors dry between layers. Then I add the diamond patterns with ultramarine blue and the flowers with burnt sienna.

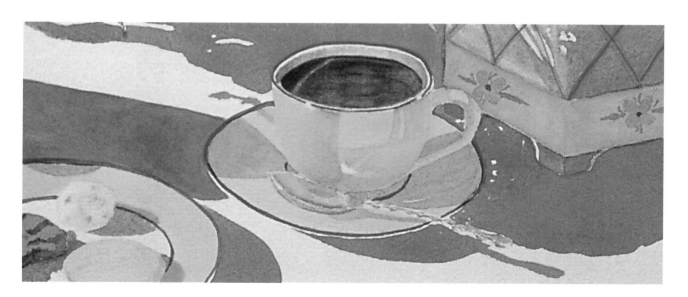

◄ TEACUP The shiny spoon reflects the colors from the cup and the sky, so I paint it with yellow, blue, and gray. I mask off the highlights on the edges first and then remove the mask when the colors are completely dry.

BUILDING ON AN UNDERPAINTING

with Rose Edin

Watercolor is an exciting medium because you can control the flow of color or let it run and bleed and blend on its own, creating wonderfully surprising "happy accidents." And you don't always have to paint by building up your values from light to dark; you can also start your paintings with a solid or multi-colored underpainting and build up layers on a colored base. Either technique is sure to result in a beautiful, stimulating painting.

1 At the center of my damp paper, I begin by washing in lemon yellow. Moving outward, I add scarlet lake and finish at the top and bottom with cobalt blue. To aid the color blend, I tilt the painting in different directions until I achieve smooth transitions. This underpainting establishes the colors and the areas of light, middle, and dark values I want in the final painting.

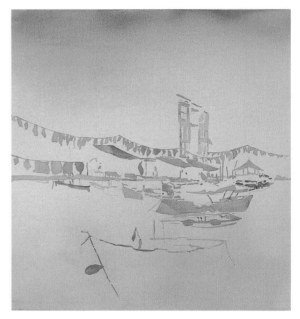

2 When the underpainting is completely dry, I block in my composition with pencil. To save my light values, I apply liquid frisket (tinted gray) with an old, fine round brush. I cover the flags, awnings, window frames, dock, and portions of the boats and buoys. For the very fine lines, such as the string that links the flags, I apply the mask with the edge of a palette knife.

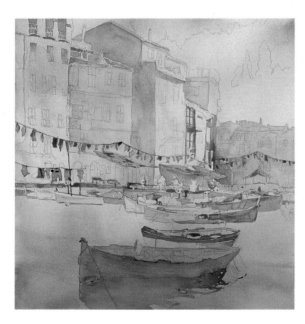

3 For the next stage of my painting (and subsequent stages), I switch to a large round brush. First I apply a light wash of cobalt blue to establish the background buildings, the shadowed sides of the foreground buildings, the shadows below the hanging roofs, and the recessed upper windows. I also glaze over the darker areas of the boats with cobalt blue, and I use a more concentrated glaze of the same color for the dark shadows and reflections. Here you can see how the underpainting has helped me place my colors: The blues at the top and bottom establish the bases for the sky and water colors; the light, warm yellow and reds in the center will draw the eye in to my focal point—the sunlit sidewalk and buildings.

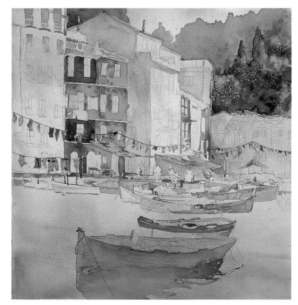

4 For the distant trees, I apply the colors individually and tilt my paper to help them blend: I begin with lemon yellow where the sun hits, adding Antwerp blue for a light green and even more blue in the shadows. I paint subtle tree shapes in the distance with Antwerp blue, adding permanent magenta in the right corner. The warm building in the center is mostly cadmium orange, with lemon yellow and quinacridone gold in the highlights and scarlet red and permanent rose in the shadows. I use the same colors on the shadowed buildings, but the reds interact with the blue underpainting to create a cool purple. I let more of the yellow underpainting show in the areas of direct sun and more blue in the areas of shadow.

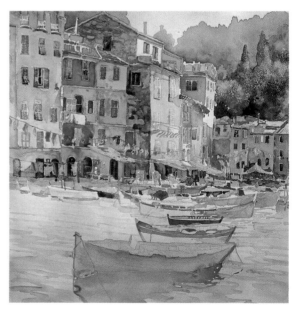

5 The foreground buildings are cadmium orange, with lemon yellow for highlights and reds for shadows. For the central building, I paint around the bricks on the shadowed side with cadmium orange. Then I use dark values of cadmium orange, lemon yellow, and my reds for the distant buildings. I paint around the door frames and shutters with a lemon yellow and cobalt blue mix, along with darker values of Antwerp blue, permanent magenta, and scarlet lake. Then I paint ripples in the water starting at the upper right with lemon yellow and cobalt blue. As I move down, I add more blue and then scarlet lake. I paint under the boats with Antwerp blue, sometimes adding permanent magenta. The lighter water is cerulean blue.

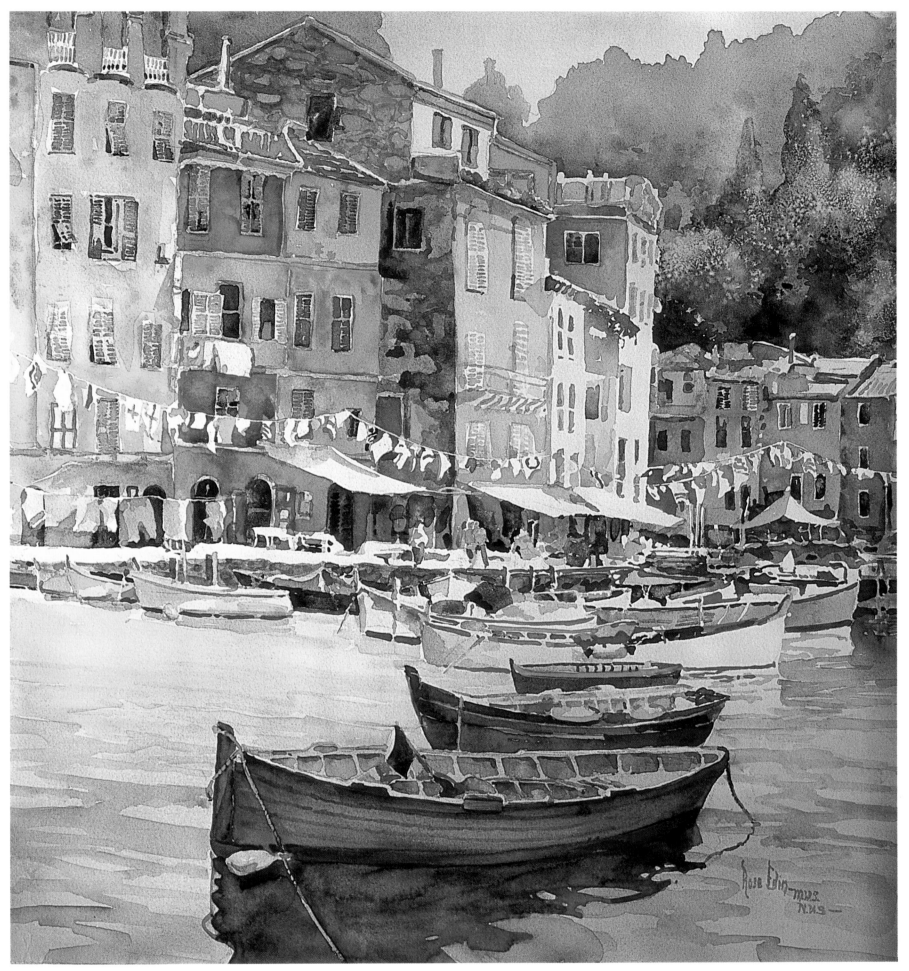

6 When dry, I gently rub off the mask with an eraser (your finger will work as well). I add detail to the flags by painting on random patterns and colors from my palette, using matching light washes for the clothesline underneath. Then I lightly block in some figures on the edge of the harbor, again randomly selecting colors from my palette. For the foreground boats in shadow, I glaze cobalt blue and Antwerp blue separately, using darker values for the outer lines and the edges. For the boats in the warmer central area, I apply scarlet lake and permanent magenta glazes, which I also apply over the highlights and the ropes.

USING GRANULAR COLORS

with Geri Medway

Let the paint work for you when depicting rough surfaces by using granular colors. A granular color is one that has a lot of sediment in it, which separates from the water when diluted. As these paint particles settle down into the crevices of the paper, they create organic-looking, multicolored hues. You've seen how transparent colors are best for multiple glazes; now learn how to take advantage of the variegated effect you get by mixing granular colors together.

WHICH COLORS ARE GRANULAR?

Granular colors are primarily earth tones mixed from minerals. The blues are cerulean blue, manganese blue, cobalt blue, and ultramarine blue. Some other granular colors are raw sienna and raw umber (the yellows), and burnt sienna and cobalt violet (the reds). Beautiful, grainy greens, violets, and browns can be mixed with all of these colors. Experiment by applying any of the granular colors over an initial wash to add some textural excitement to your paintings.

APPLYING THE PIGMENTS

To get the maximum granulation effect, keep your paper flat, mix the paint well with each brushful, put it on the paper once, and leave it alone. Then sit back and watch the colors settle into the surface and separate as they dry! Occasionally, try glazing over them when they are dry, but do so quickly and with a minimum number of brushstrokes; otherwise you could lift them or turn them muddy.

CREATING TEXTURE Because these old buildings are made out of stone and stucco, granular colors are the perfect choice to show their pitted, coarse textures.

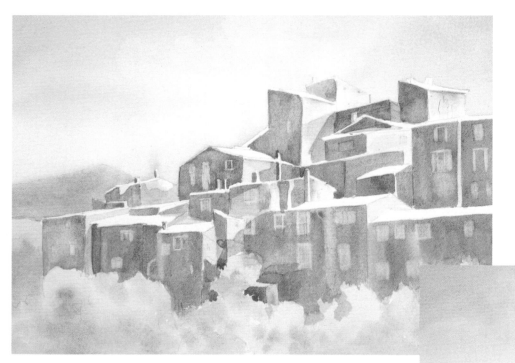

1 At first, this town seems difficult to draw until I focus only on the shapes. Once I look at the buildings as though they are stacked blocks, I find that drawing them is actually easy. Next I wash in the sky and lift out some clouds with a tissue; then I add a thin layer of raw sienna on the shadowed sides of the buildings.

2 Here I apply the granular colors. First I glaze manganese blue for the shadows, and then I darken other areas with cobalt violet, raw sienna, or burnt sienna. The darks add just the right amount of definition to the buildings in this quiet hillside town in Italy.

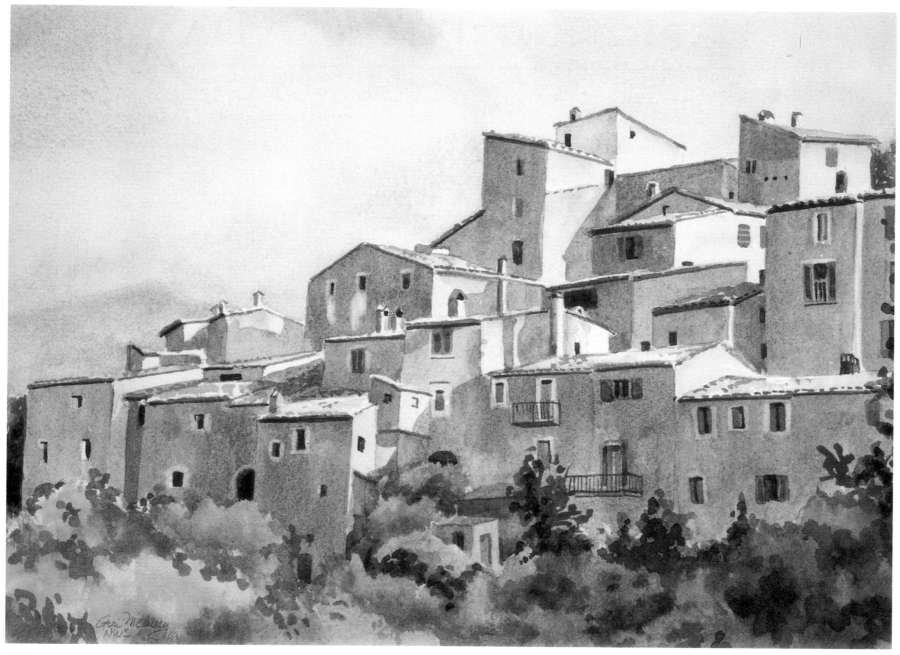

3 The darker greens (mixes of sap green, phthalo blue, and alizarin crimson) "anchor" the buildings to the ground and help the eye move into the picture.

MAKING A GRANULATION CHART

It's a good idea to mix the granular colors together in different combinations, label them, and keep a chart handy for reference. Use watercolor paper for your chart, not ordinary paper, because you'll want to take note of how each color settles into a rough-textured paper.

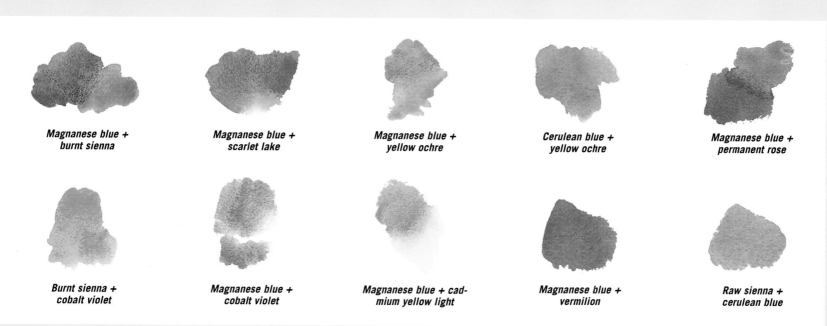

Magnanese blue + burnt sienna	*Magnanese blue + scarlet lake*	*Magnanese blue + yellow ochre*	*Cerulean blue + yellow ochre*	*Magnanese blue + permanent rose*
Burnt sienna + cobalt violet	*Magnanese blue + cobalt violet*	*Magnanese blue + cadmium yellow light*	*Magnanese blue + vermilion*	*Raw sienna + cerulean blue*

17

DEPICTING TIME OF DAY

with Barbara Fudurich

An essential part of painting outdoors is determining when to paint. The time of day determines the strength of the light, the depth of the shadows, and the intensity of the colors in nature. Barbara has found that some of the best times to paint are at dawn and at dusk, when the sun is low in the sky. That's when the light strikes at an angle, producing long, slanting shadows and exciting contrasts of color and light. She also enjoys painting in the late afternoon—often called "the golden hour"—because the colors in the objects appear warm and rich, while the shadows are cool and long. Sometimes a subject one would normally overlook in the morning or at midday becomes intriguing in the late afternoon light, such as this building that acquired a beautiful glow as the sun moved west across the sky—a perfect subject for a painting.

1 I start with a 1-inch flat brush with a mixture of raw sienna, permanent rose, and a touch of burnt sienna to wash over the stucco areas: the building, the wall by the stairs, and the plant stand. Then, still using the flat brush, I wash in cobalt blue for the sky.

2 I switch to a large round brush to add another layer of the stucco color behind the arch, setting that area back in shadow. When it's dry, I add yet another layer, this time painting the color around the upper curve of the arch and adding a swipe of cadmium orange for the light reflected from the ground. For the final layer, I start in the upper-right corner with burnt sienna, and then I charge in dioxazine purple. This makes the shadow darkest in the deep recesses and lighter where it is closer to the strong light of day.

3 Next I develop the foliage of the bougainvillea using a round brush. I start with a wash of aureolin yellow for the lightest values and then charge in mid-value greens with a mix of aureolin yellow and cobalt blue. For dark greens, I use aureolin yellow mixed with ultramarine blue. While the color is still damp, I charge in spots of permanent rose for the flowers, letting the colors blend slightly. I use the tip of my brush to dot in pure permanent rose for the darkest flowers. I paint the potted plant in a similar manner, and then I block in the foreground plants and the palm tree to the right of the staircase with aureolin yellow.

4 Now I paint the trunk of the palm tree with a lavender-gray mix of cobalt blue, permanent rose, and raw sienna. Working from light to dark, I paint the foreground foliage, starting with aureolin yellow and then charging in shades of green and spots of raw sienna and burnt sienna. For the darkest greens, I use phthalo blue mixed with burnt sienna. I add palm branches in the foreground foliage with various greens and use permanent rose for the flowers. Then I add more bougainvillea beneath the balcony.

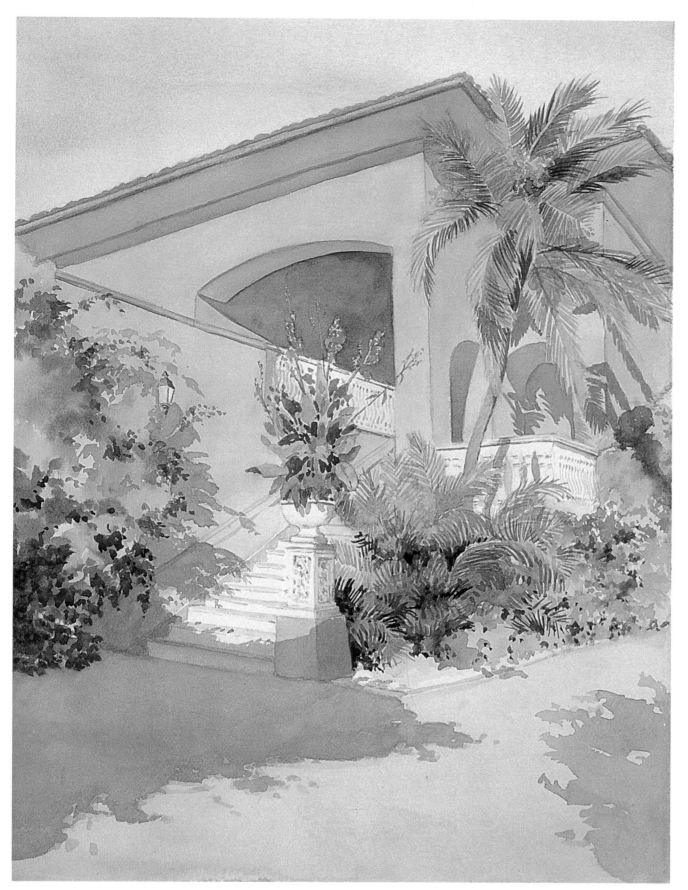

SUNLIT STUCCO

*Raw sienna +
burnt sienna +
permanent rose*

**MEDIUM GREEN
FOLIAGE**

*Aureolin yellow +
ultramarine blue*

LIGHT FOLIAGE

*Aureolin yellow +
cobalt blue*

**DARKEST GREEN
FOLIAGE**

*Phthalo blue +
burnt sienna*

SHADOWED STUCCO

*Cobalt blue +
vermilion*

RED FOLIAGE

*Vermilion +
raw umber*

5 Next I use the stucco mix of raw sienna, permanent rose, and burnt sienna to paint the underside of the overhang, swiping in cadmium orange to indicate reflected light. When the paint is dry, I apply cobalt blue mixed with vermilion along the cast shadow from the roof. I develop the archways first with the stucco mix and then charge in the lavender-gray mix. I add permanent rose to the stucco mix for the shadows on the building and ground. All the afternoon shadows are long and cool, but I use more blue in the deepest shadows to really accentuate the coolness. To finish, I paint burnt sienna mixed with dioxazine purple around the flowers in the planter.

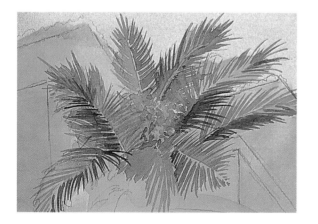

◄ PALM DETAIL My medium round brush comes to a nice point, so I use it to paint the palm fronds with an assortment of the greens on my palette. I add an occasional touch of raw sienna or burnt sienna, both for variation and to add a brown tinge to some fronds and at the top of the tree. All my brushstrokes follow the direction of the palm fronds' growth, from the center outward.

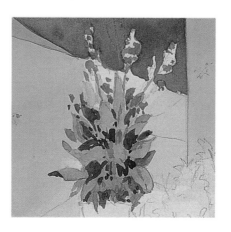

◄ PLANT DETAIL Using the medium green mix of aureolin yellow and cobalt blue, I paint the foliage inside the planter, defining the leaves around the outer edges. The leaves have dark red undersides, so I use vermilion darkened with raw umber. I dip the tip of my brush in vermilion and add blossoms on the stems. Then I add a few touches of the dark green mix of aureolin yellow and ultramarine blue to give the plant form.

PAINTING WHITES

with Carol Patterson

A simple landscape rendered with a limited palette can be just as striking as one filled with many vivid colors. It's especially intriguing to focus on a white subject, such as a sky full of clouds, a field of white flowers, or a meadow blanketed in snow. Painting white subjects is a great exercise in learning to see the nuances of color in what seem to be colorless subjects. You'll be amazed at the range of colors you see in white when you take the time to really examine your subject.

White doesn't necessarily mean the absence of color; in fact, white objects are full of reflections of the colors of things that surround them. For instance, white clouds pick up the intense colors of a sunset, and white snow reflects the colors of nearby landscape elements and even the sky. And

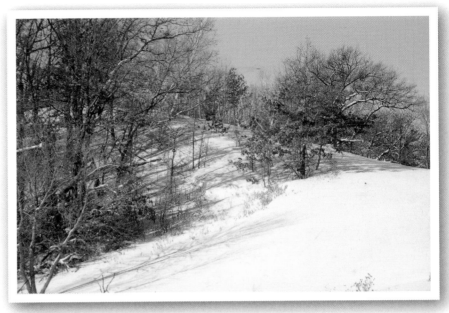

CAPTURING THE LIGHT Light changes quickly outdoors, which makes it a challenge to paint all the shadows and highlights before they shift. I use photographs as references so that I can capture the shapes of shadows and shades of colors of a particular moment. Photos don't always show all the nuances of color in a scene, however, so it's also important to take detailed notes about the variations you see—especially in the "white" areas. You might even try to make a quick watercolor study on location and then use it and your photo to create a detailed painting in your studio.

you don't have to paint exactly what you see; you can change the intensity or richness of the reflected colors to enhance your composition if you like. Keep this in mind as you paint, and save the white of the paper for only the lightest highlights. In a well-planned painting, you can retain white areas by painting around them or by using masking fluid. Artist Carol Patterson uses both methods of saving pure white highlights in this snow scene, while the shadowed patches of snow reflect all the other colors in the landscape. Here she demonstrates how even the subtlest shading contributes to a beautifully defined hillside of powdery white snow.

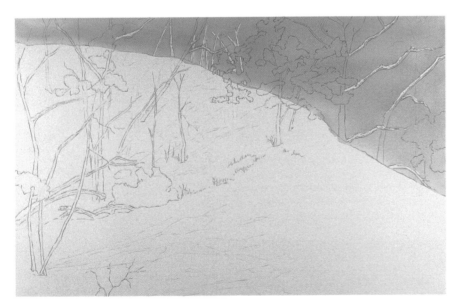

1 I start with a very light sketch of my scene on watercolor board. Before I begin painting, I use an old, medium round brush to apply liquid frisket to areas I want to remain pure white: the snow-covered branches and some spots in the thicket of trees where the sun is shining through. When dry, I use a large flat brush to wet the entire sky area—even over the sketch of the tree leaves and stems. Then, with a large round brush, I wash in a medium value of cobalt blue, tilting my paper in all directions to even out the blend.

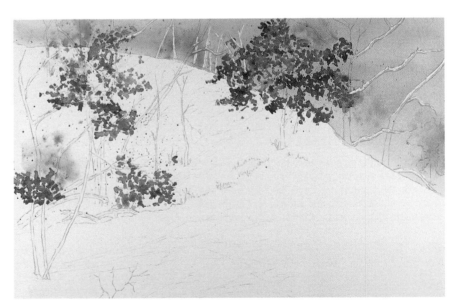

2 Before I paint the leaves, I protect the surrounding area by covering it with cardboard. Then I spray spots of water over the support, leaving plenty of dry space for the sky. Next I load a large brush with burnt sienna and spatter it on. I use the same technique to apply cobalt blue and then cadmium red light. Finally, I spatter on raw sienna and then cobalt blue for the cooler leaves. To help the colors mix on the paper, I gently tilt the paper in all directions. Then I reposition my cardboard covers to protect the foliage where I want harder edges and use a fine mister to create softer edges in the remaining leaves.

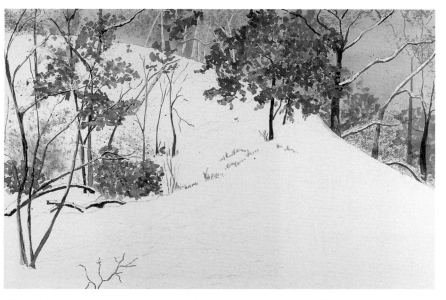

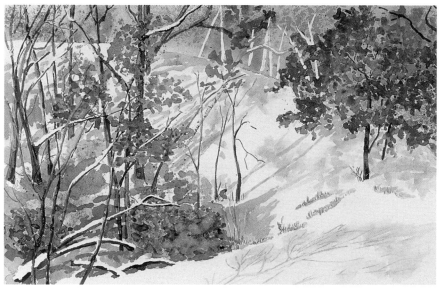

3 Next I use a dry sea sponge with a mix of burnt sienna and cobalt blue to suggest branches along the edge of the hilltop and in the tops of the birch trees. When dry, I repeat the process with a mix of dioxazine violet and burnt sienna. After this dries, I use a medium round brush with diluted burnt sienna to highlight the leaf clusters. I also highlight the trees in the thicket at left with diluted raw sienna. Where I sponged, I make the trees denser by painting in a thin mix of burnt sienna and cobalt blue. Then I use three colors for the tree trunks: raw sienna on the sunny sides and alizarin crimson and cobalt blue on the shadow sides. I use a rigger brush with raw sienna to add thin blades of grass peeking out from the snow.

4 Working from the warm foreground to the cool background, I paint shadows in the thicket starting with permanent magenta, switching to cerulean blue, and ending with cobalt blue in the distance. I add four tree trunks deeper into the thicket, painting them as in step 3. When dry, I use a damp brush to lift out sunlit spots. I "fix" the two trunks in the foreground by wetting and scrubbing out the area between them and repainting the branches. For the shadows in the snow, I work from warm to cool again, using permanent magenta and dioxazine violet in the foreground and cobalt blue and cerulean blue as I move into the distance. The shadow colors vary because they pick up colors from all the surrounding objects. When dry, I rub off the liquid masking (you can use your finger or a rubber eraser).

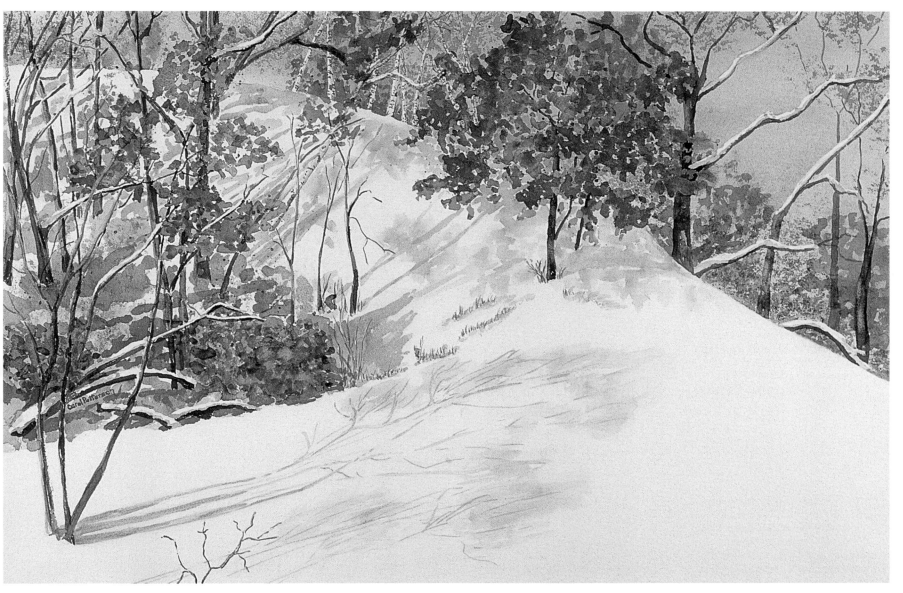

5 I add dimension to the snow on the tree limbs by shading the lower edges with a diluted mix of cobalt blue and burnt sienna. I also apply light shadows to the snow where needed, producing a wide range of reflected color in the white snow. I pick up a watery mix of cobalt blue and dioxazine violet with my rigger brush to paint a few darker grasses and the rings and spots of the birch tree. Then, to make the birch trunks more visible, I use a medium round brush to apply a thin mix of cobalt blue and burnt sienna to the negative spaces (the spaces between the trunks and branches) behind them. I also use this mix to darken along the back edge of the hill.

CREATING DEPTH WITH COLOR

with Barbara Fudurich

When painting outdoor subjects, you can use a variety of techniques to convey a sense of depth. In this painting, Barbara Fudurich relies heavily on the use of atmospheric, or aerial, perspective. All the impurities in the air (such as moisture and dust) block out some of the sunlight, so objects in the distance appear less distinct and with softer edges than those in the foreground. And it is the longer, red wavelengths of light that are filtered out, so objects in the distance also appear cooler and bluer. To paint a scene using atmospheric perspective, give the elements closest to the viewer the brightest colors, keeping them sharply in focus and highly detailed. For objects that are farther away, use increasingly less detail, with weaker, cooler colors, as in this scene of the famous red rocks of Sedona, Arizona.

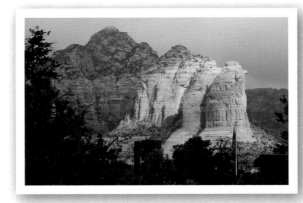

SEEING CHANGES IN VALUE I was struck by the powerful effect of strong sunlight on these beautiful rocks in Sedona. I decided to exaggerate the aerial perspective for my painting, veiling the distant rock in mist and deepening the shadows. This exaggeration draws the viewer's attention where I want it: on the sunlit section of rocks in the foreground.

PAINTING THE ROCKS

STEP ONE To paint the foreground rock formation, I use a large round brush and a peach wash of quinacridone burnt orange mixed with permanent rose, vermilion, and a touch of cobalt blue. I stroke in each layer of strata, horizontal and vertical, painting down to the tree line in the foreground. I add green shrubbery on the right, using aureolin yellow mixed alternately with cobalt blue and cerulean blue.

STEP TWO After the first wash has dried, I build up the forms by painting on a second layer of the same mixture, but this time I use more pigment and less water. Again I'm careful to make my brushstrokes follow the direction of the strata. I don't cover the entire expanse of the rock again because I want the sunlit portions of the rock to remain the lighter peach color.

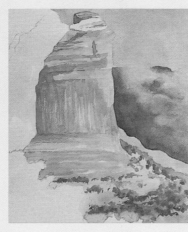

STEP THREE Once the paper is dry, I continue building up my darks. I return with yet another darker value of the same mixture for the deep shadows on the shadowed (left) side of the rock and for the dark crevices. To paint the smallest areas, I use the tip of the brush.

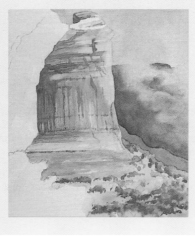

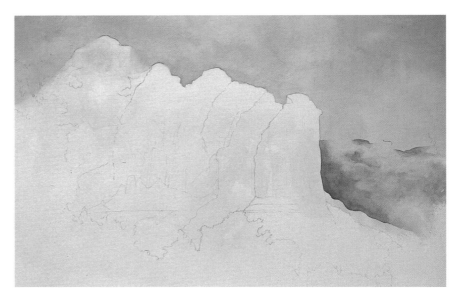

1 I cover the paper with a variegated peach wash of quinacridone gold and vermilion. Then I wash in a stormy sky with a mix of quinacridone gold, permanent rose, and cerulean blue, varying the proportions of the colors as I work into the mountains at lower right to produce greenish and lavender tones. While the paper is still damp, I dab the edge of the mountaintops with a tissue to create clouds over the ridge. I use a flat brush to paint a darker wash over the mountains at right to push them farther into the distance. While the paint is damp, I lift out misty clouds with a tissue.

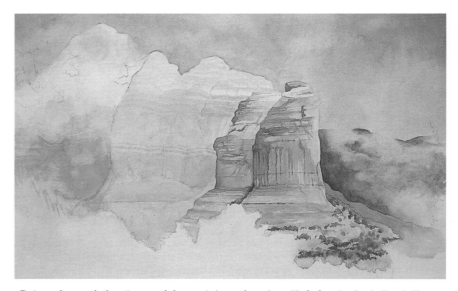

2 I continue painting the remaining rock formations (see "Painting the Rocks" at left). First I use a large round brush to lay in a peach wash of quinacridone burnt orange mixed with permanent rose, vermilion, and a touch of cobalt blue, painting all the way over to the left edge of the paper in a somewhat uneven manner (to establish shading). Then I build up the layers as I did for the first rock, always making my brushstrokes follow the direction of the strata of the rocks, whether horizontal or vertical.

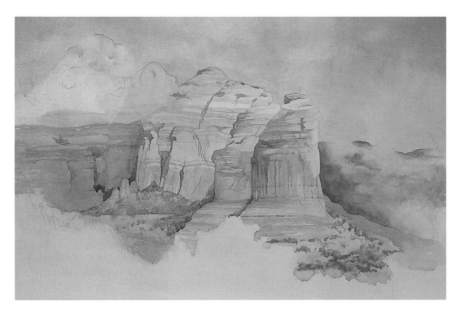

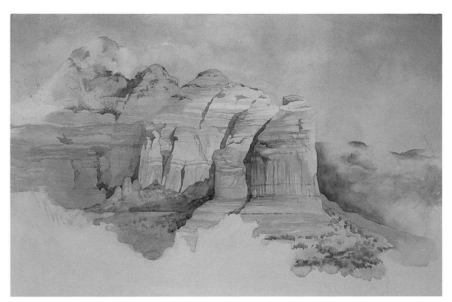

3 I lay another uneven peach wash over the remaining rock formations, continuing to the left edge of the paper. Then I finish painting them as I did the first. I also paint the lower slopes of the mountains, washing over them with peach and then adding the green shrubbery. I place the darker shadows with the tip of my brush, using a mixture of vermilion, permanent rose, and cerulean blue. The recessed part of the mountain on the left is completely in shadow, so I cover the entire area with this darker mix of the same colors.

4 With a blue-toned mix of quinacridone gold, permanent rose, and cerulean blue, I form the shadowed mountaintops; the cool color makes this area seem to recede. While the color is damp, I lift out clouds with a tissue. I add green shrubbery, but because the area is in shadow, I mix only aureolin yellow with the cooler cerulean blue. Then I place the shadows cast by the rock formations using vermilion mixed with ultramarine blue. I also glaze this color over the recessed side (far left) of the mountain to set it back farther.

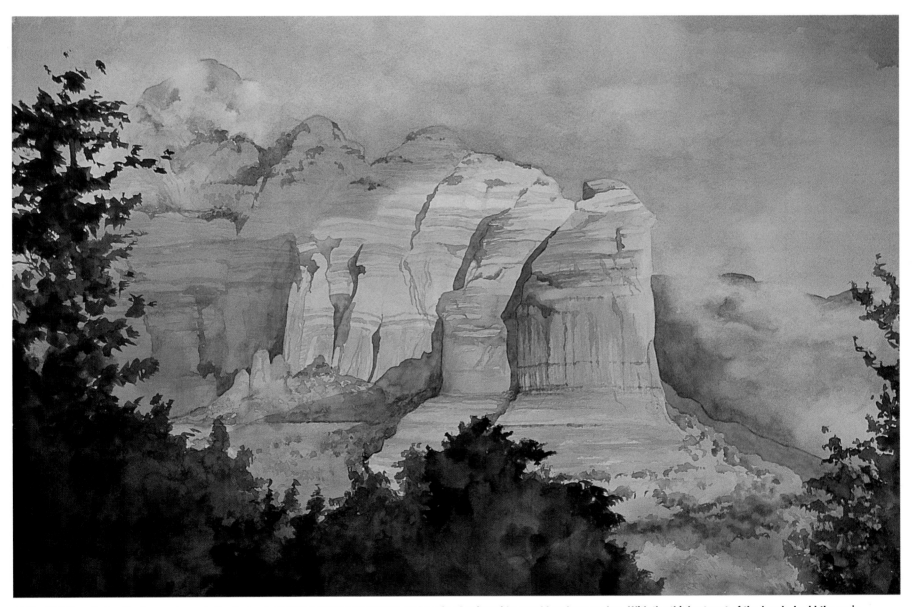

5 I add foliage below the lower slopes in the foreground with a large round brush and a mix of quinacridone gold and raw umber. With the thickest part of the brush, I add the main portions of the foreground trees at right with a dark mix of phthalo blue and quinacridone burnt orange; then I pull out branches with the tip of my brush. At left, I paint an evergreen tree and then create denser foliage as I move down the page. To finish, I dip a rigger brush in ultramarine blue mixed with quinacridone burnt orange and paint bare tree branches.

EVOKING A RESPONSE

with Barbara Fudurich

Gaining an understanding of how color affects mood will help you convey the correct "feel" in your paintings, as demonstrated in these two paintings of the same mission. In the first painting, the sun is shining and the sky is blue; the lighter, warmer colors evoke a happy, carefree feeling. But in the second painting, the sky is filled with storm clouds, and the darker, cooler colors create a heavy, moody sky that makes it seem more melancholy. The subject itself is the same, but the colors chosen for the paintings have a drastic effect on the way the viewer feels looking at each one. As you practice observing and mixing colors, you'll learn to express an array of emotions in your outdoor paintings.

1 For my sunny scene, I wash a cobalt blue sky over my sketch and charge in green-gold leaves. Then I wash sap green with a touch of raw umber over the bottom foliage. I paint the dome with an orange mix of quinacridone gold and vermilion; then I add more water to the mix and wash it over the right side of the building. I charge in dark greens in the foliage with various mixes of sap green, raw umber, and ultramarine blue. Then I use a liner brush to pull out the dark green color to create the palm fronds.

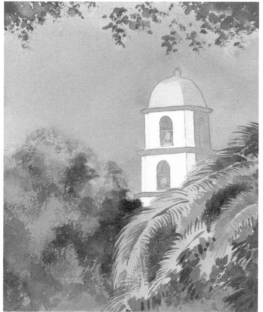

2 I drybrush greens in the lower foliage and add darks to the overhead trees. Next I glaze the orange mix from step 1 over the right, shadowed side of the dome. Then I use a warm gray mix to paint the building shadows (see "Mixing Neutrals" on page 28). Keeping warm tones in the shadows (see box at right) helps establish the cheerful mood.

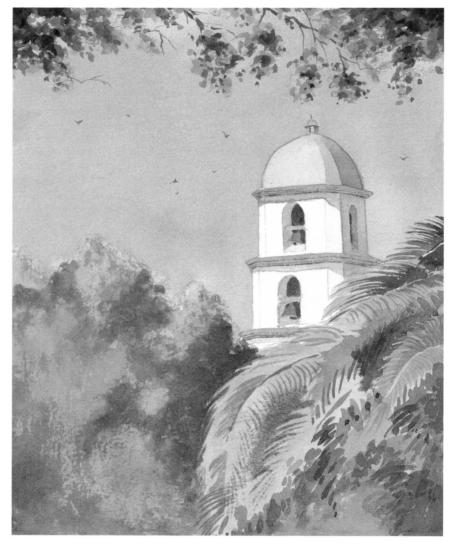

3 I add another layer of darks to the overhanging trees and then paint branches with a liner brush and a mix of cobalt blue and raw umber. Using the gray mix, I add details to the top of the dome, painting over the shadows to blend the value transitions. Then I add more shadows under the eaves, charging in the orange mix of quinacridone gold and vermilion to show patches of reflected light. Using a purple mix of ultramarine blue and vermilion, I paint the inside of the arches; then I use the liner brush to drybrush lines along the eaves and to add birds in the sky. I add a touch of the purple mix to the orange to paint the darkest shadows of the dome, and I apply strokes of the orange mix over a few palm fronds to unify the colors. Now my bright, sunny painting is complete.

WARM AND COOL COLORS

As you've learned, colors are often classified by temperature; the so-called warm colors are the reds, oranges, and yellows, and the cool colors are the greens, blues, and purples. But there are variations in temperature within every family of color as well. For example, as you can see in the chart below, a red with a little more blue in it, like permanent rose, will appear cooler than one with more yellow, like vermilion. And warmer colors generally seem more peppy and enervating, whereas cool colors seem more sedate and peaceful. Although there are similarities in my color mixes, these subtle differences in temperature contribute to producing the distinct mood of each piece.

WARM DOME

Burnt sienna + permanent rose + dioxazine purple

COOL DOME

Quinacridone gold + vermilion

1 After sketching my composition, I paint the palm branches with frisket to save the white of the paper. When it dries, I wash over the stormy sky with a dark color, and the frisket repels the paint on the palms. When the sky is dry, I use a 1-inch flat brush and apply a dark gray mix of raw sienna, permanent rose, and cobalt blue. As I work, I use a slightly damp ("thirsty") brush to soften some of the hard edges.

2 I use green mixes (see color samples below) to block in the tall tree on the right and some distant foliage, then deepen the sky around the dome with the dark gray mix to convey the solemn mood. When this is dry, I gently remove the frisket with a rubber eraser and then paint the palm tips with quinacridone gold. I also wash in greens for the base color of the foreground foliage. When this dries, I apply wax to the lower palm fronds.

3 I paint the dome with a mix of burnt sienna and permanent rose, adding dioxazine purple to the shaded sections to enhance the somber mood. I switch to a cool gray mix to paint the tower's shadows, and I define the inner recesses using a mix of burnt sienna, dioxazine purple, and ultramarine blue. I also add the deciduous trees with a mix of burnt sienna and raw umber and paint some more palms with muted green mixes.

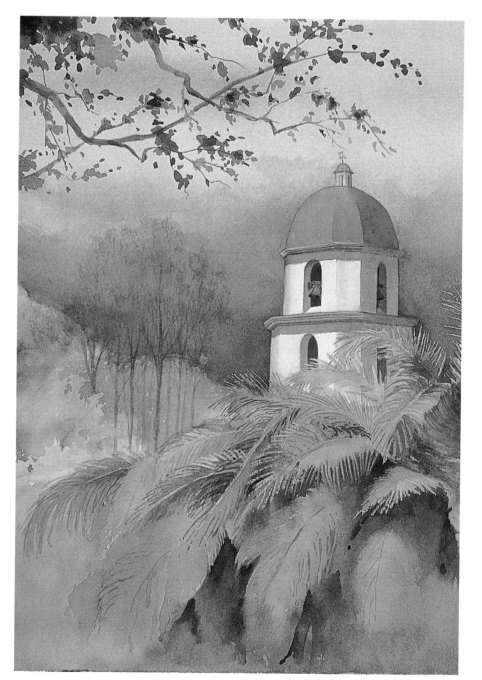

Aureolin yellow, cobalt blue, raw sienna, ultramarine blue, aureolin yellow, cerulean blue, cadmium yellow medium

MIXING GREENS I keep one of the wells in my palette exclusively for mixing greens. Rather than developing just one color as I paint, I keep dipping into the different yellows (aureolin yellow, cadmium yellow medium, raw sienna, quinacridone gold, burnt sienna, and quinacridone burnt orange) and blues (cobalt blue, ultramarine blue, or cerulean blue).

MASKING TECHNIQUES

I use different methods for "saving" white or light values in watercolor, depending on the effect I wish to produce. Masking fluid leaves a sharp edge when it's removed, which creates a more distinct shape than other techniques do. When I want a more subtle transition, I "lift out" the light values from dark paint. Sometimes I use wax to resist paint and create texture, and when I'm working with large light areas, I simply paint around them.

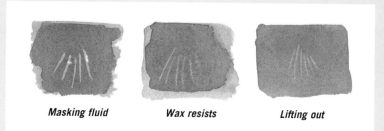

Masking fluid *Wax resists* *Lifting out*

4 I finish the archways in the tower and use my small round brush to paint the lines along the edge of the roof. Next I paint the centers and edges of some of the palm fronds, using a damp brush to keep the edges soft. I add a tree branch in the upper left corner with burnt sienna and raw umber, and then paint sparse leaves using a dark green mix of burnt sienna and ultramarine blue. I also add some darker green leaves using a mix of aureolin yellow and ultramarine blue that is grayed with a touch of raw umber. Now compare this cool, muted painting with its warm, sun-filled counterpart on the opposite page to get the full impact of how color affects mood.

COLOR IN LIGHT AND SHADOW

with Geri Medway

Capturing the brilliant interplay between light, shadow, and color is one of the most fascinating aspects of landscape painting. The natural contrasts between light and dark can create a dramatic effect in the late afternoon or convey a peaceful mood in the early morning. Both are ideal times for rendering light because the sun is lower in the sky, creating both long, cool shadows that recede and warm sunlit patches that spring forward.

DEPICTING SUNLIGHT

Where you place your lights and shadows will depend on the placement and direction of the sun. The sun creates highlights on the areas it hits directly, and the shadows fall on the opposite sides. But light isn't present only in sunlit areas; the shadows also contain a range of values of cool colors, with spots of reflected light that have bounced off surrounding objects. Here Geri Medway uses a variety of colors and values to render the shadows in this sun-dappled eucalyptus grove.

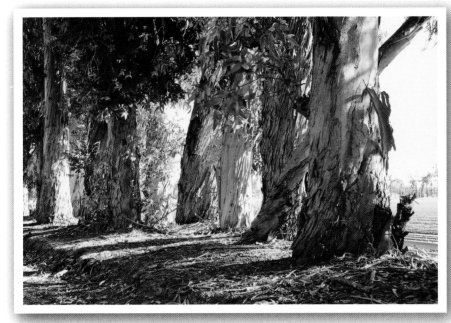

SETTING A MOOD Often the lights and shadows of a scene attract my eye more than the subject itself does. For example, when the light comes from the side, such as in the morning or evening, the shadows are vivid and full of fascinating negative shapes. The tranquil shades of blue and purple in this backlit stand of eucalyptus trees set a cool and relaxed tone that wouldn't be possible at another time of day.

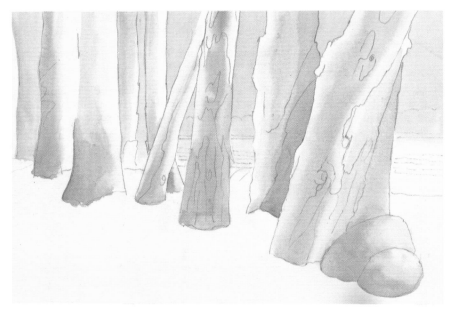

1 I roughly block in the textures and shadows with pencil. Then I wash ultramarine blue mixed with cerulean blue over the sky area. (I use two large round brushes: one for pigment and the other for the clear water of my graded washes.) When dry, I underpaint the trees and rocks with medium values of cobalt violet and ultramarine blue. (These colors will visually mix with subsequent layers.) I also wash cerulean blue over the right side of the tree in the center of the painting and between the other colors on the rocks.

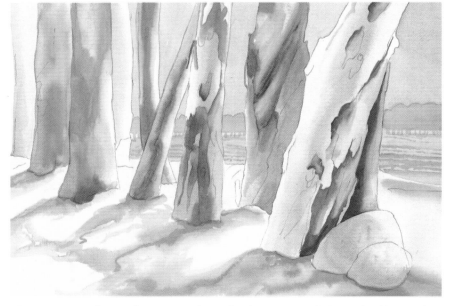

2 When dry, I paint the distant trees with a mix of sap green and ultramarine blue. I paint the field with a wash of burnt sienna and add uneven rows of darker values. Next I wash over the ground with a mix of burnt sienna and cadmium orange. I apply a darker value for shadows, using just a little cobalt violet toward the left corner. I vary the values of burnt sienna on the trees, lighter at left and darker at center. At far right, I apply a cooler brown with a mix of burnt sienna and ultramarine blue.

> **ARTIST'S TIP**
> If the value looks correct when it's wet,
> it's wrong! Almost all colors dry to a
> lighter value.

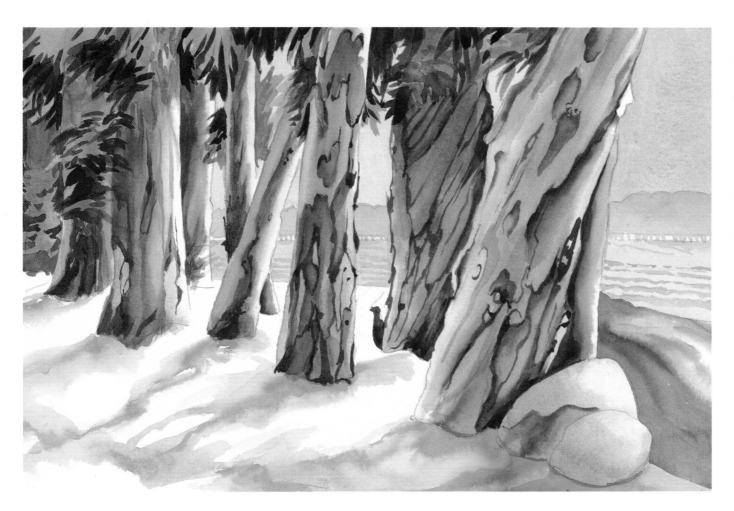

3 I glaze the trunks with ultramarine blue and a little burnt sienna. When dry, I paint the leaves with a light mix of raw sienna and cerulean blue. I also apply a darker value of this mix with more cerulean blue for blue-green areas. I charge in cobalt violet behind the center trees and on the ground. Then I apply sap green, ultramarine blue, and a bit of alizarin crimson to the leaves. At far right, I wash in burnt sienna and, when dry, ultramarine blue with a touch of burnt sienna. When dry, I paint shadows with a mix of burnt sienna and ultramarine blue.

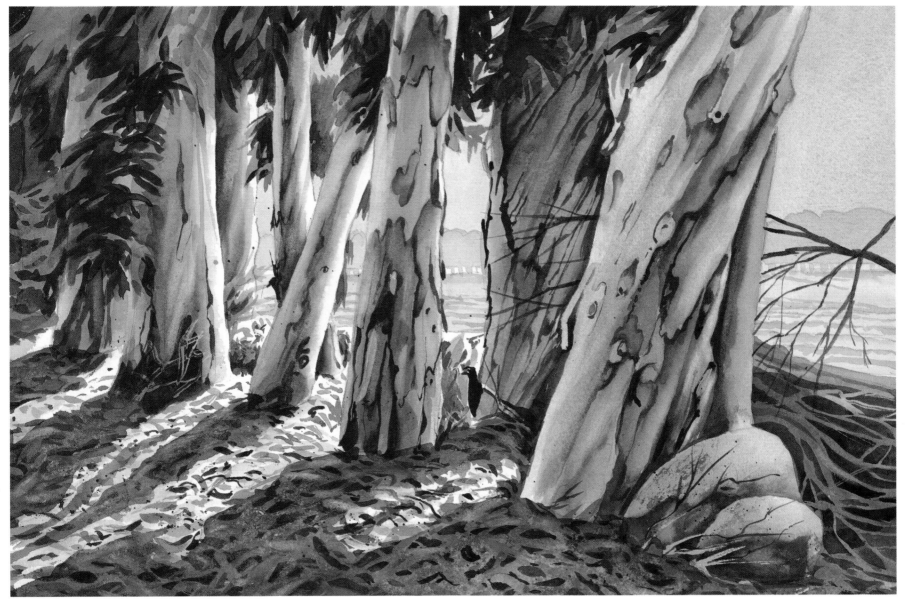

4 To preserve the light values in the foreground, I mask off leaf shapes on the ground and twig shapes at the base of the rock and tree with liquid frisket. When dry, I paint overlapping leaves, alternating between burnt sienna, cobalt violet, and a mix of raw sienna and cerulean blue. After I spatter the ground, I mix burnt sienna and ultramarine blue to spatter the rocks, glaze over the trees and rocks, paint twigs and branches, and fill in the negative spaces at right. When dry, I remove the masking. Then I paint the tree shadows on the ground with a glaze of ultramarine blue mixed with a touch of burnt sienna. I also finish the leaves on the ground and scrub out highlights from the trunks. Finally, I glaze over the hanging leaves with a mix of sap green and ultramarine blue.

Painting with Neutrals

with Barbara Fudurich

Often a beginner's first instinct is to use the brightest and most vibrant colors on the palette, believing that this the best way to ensure a beautiful painting. But nature is filled with an amazing array of gorgeous neutral browns and grays, with many nuances of reds, blues, purples, and greens. And using a variety of neutrals in your painting will allow the brighter spots of color to stand out even more, as shown in this garden painting. Here Barbara Fudurich uses plenty of purplish shades of gray and white to set off the more vivid greenery and the few brightly colored flowers. Also, she echoes the shades of the purple flowers in the neutrals for a sense of unity in the painting.

MIXING NEUTRALS

To create your own neutral colors, mix the three primary colors (red, yellow, and blue) or two complements (red and green, yellow and purple, or blue and orange). These mixes will be more complex and richer than the neutrals straight out of a paint tube.

Viridian green + permanent rose

Raw sienna + permanent rose + cobalt blue

1 After I sketch my composition on the paper, I dampen the background. Then, making soft, abstract shapes, I charge in "garden" colors from my palette: mixes of sap green and cobalt blue; sap green, cobalt blue, and ultramarine blue; and cadmium orange and vermilion. I paint in the posts and beams with a gray mix of quinacridone gold, permanent rose, and cobalt blue, using a darker value for the closest beams.

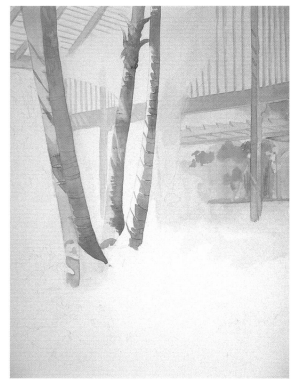

2 I pick up a gray mix of quinacridone gold, permanent rose, and cobalt blue to paint the palm trunks, varying the proportions to keep the colors fresh. First I add shadows, indicating how the sunlight is filtered through the overhead lattice. Then, using a palette knife, I scrape out a variety of horizontal lines on the damp tree trunks, allowing the color to run into the grooves. (The wetter the paper is, the darker the lines will be.)

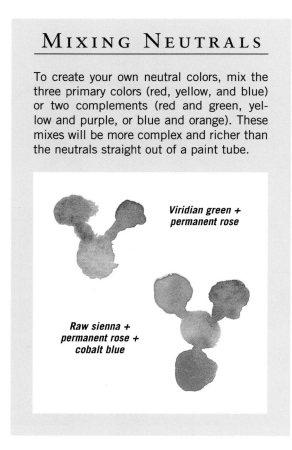

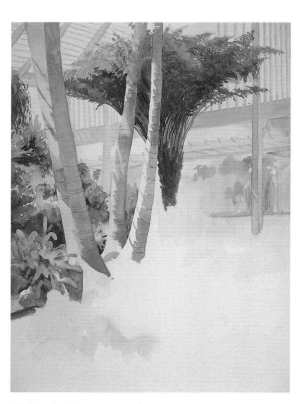

3 Next I add another section of overhead beams in the background. Then I paint the fern tree, beginning with a light wash of green-gold for the sunlit areas, then applying sap green, and continuing with progressively richer green pigments. For warmth and to tone down the color, I stroke in touches of burnt sienna. Then I add foliage between the palms.

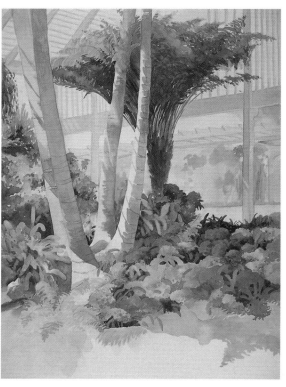

4 I wash a purple mix of cobalt blue and permanent rose over the lightest portion of the flower bed. Then I use a medium round brush to add definition, painting in the surrounding flowers and the leaves; since they are in shadow, I use darker greens and purples. (For color mixes, see the foliage detail at on page 29.)

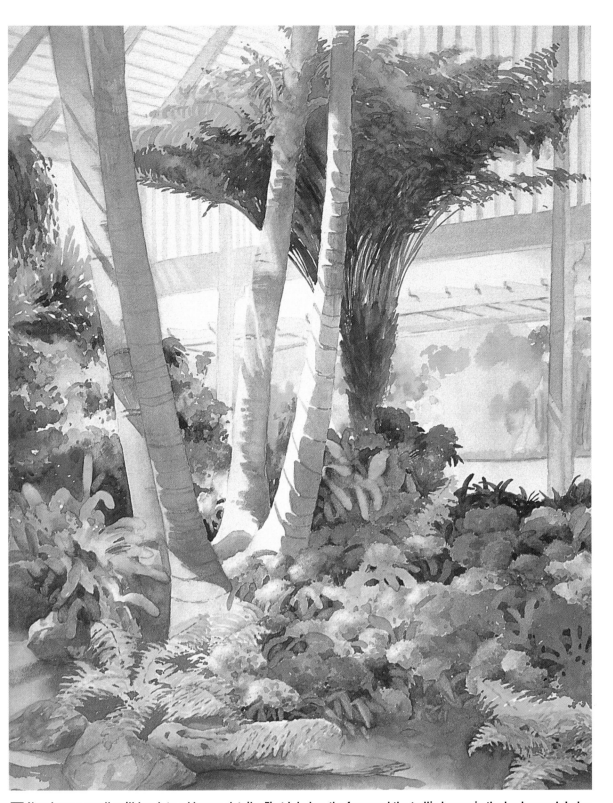

STEP ONE I want to create a believable transition from the foliage to the earth, so I paint wet-into-wet. With this technique, the burnt sienna blends smoothly into the still-wet green shadow.

STEP TWO To add the brown rock, I use a medium round brush and burnt sienna, charging in shadows with a bluish-gray mix of quinacridone gold, permanent rose, and cobalt blue. I also paint a gray rock by charging in a mix of burnt sienna, permanent rose, and cobalt blue for the shadow. I use burnt sienna for the driftwood, charging in dioxazine purple for the shadows.

STEP THREE Darker colors tend to recede, so I apply a light wash of burnt sienna over the foreground, painting around the rocks and driftwood. Then I charge in a mix of burnt sienna, dioxazine purple, and cobalt blue to create the effect of dappled sunlight.

5 Now I use a small quill brush to add some details. First I darken the ferns and the trellis beams in the background. I also wash over some of the fern leaves with cobalt blue to set them into shadow. Next I apply a light gray wash over the top of the far-left palm trunk to separate it from its neighbor. Then, to bring the front palm trunk farther forward, I lightly glaze over it with a warm gray wash. The grays I mix are very similar, but small differences in the coolness or warmth of the tone change the neutrals just enough to differentiate the trees yet still maintain the overall unity of color.

GREEN PLANT LIGHTS	*GREEN PLANT DARKS*	*PURPLE FLOWER LIGHTS*	*PURPLE FLOWER DARKS*	*RED FLOWER*
Sap green + cobalt blue	*Sap green + cobalt blue*	*Cobalt blue + ultramarine blue*	*Cobalt blue + permanent rose + ultramarine blue*	*Cadmium orange + vermilion*

CREATING COLOR HARMONY

with Geri Medway

Painting a landscape that looks natural requires a palette that allows for color harmony, or a sense of unity in hues. Color harmony gives the realistic impression that all objects in the scene are under the influence of the same light—whether it's warm, cool, pink, or blue in cast. To achieve this using watercolor, artists often stick to a few very similar hues and even subtly apply a particular hue throughout the painting. In this project, Geri Medway unifies the painting with glazes and subtle touches of cobalt violet. As a result, notice how all the colors used in the scene seem to lean toward violet, giving a soft, purple glow to the morning scene.

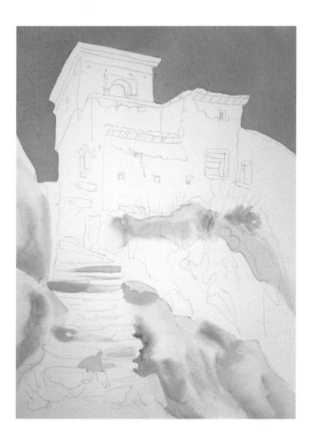

1 I choose to paint this building scene in Umbria, Italy, because the contrast between the sunlit areas and those in deep shadow was so dramatic. It seems, however, that every time I look down to paint and then up again at the scene, the shadow patterns change, so I have to work rapidly. First I sketch in the building, not allowing myself to get hung up on the details. Then I wash in the cloudless sky with a mix of cobalt and phthalo blue, holding the paper on an incline so gravity will pull the color down evenly on the paper.

> ### ARTIST'S TIP
> Try selecting an extreme viewpoint for your subject—looking sharply either up or down— to accentuate the sense of perspective.

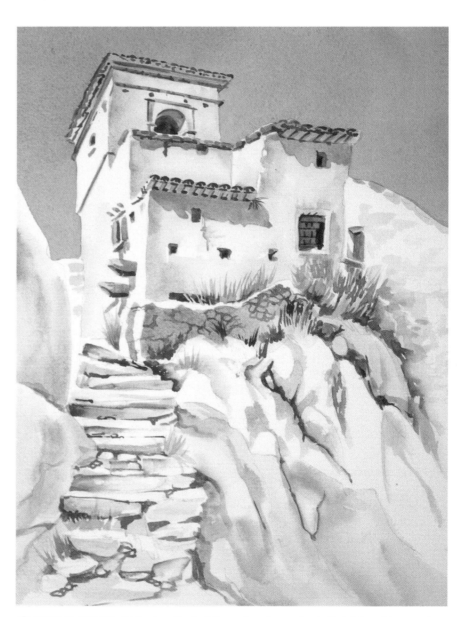

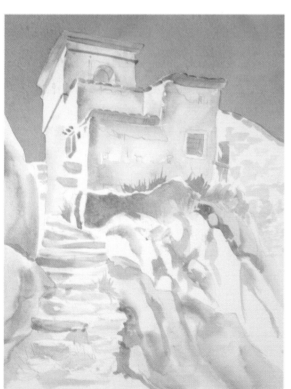

2 The colors of the building are neutral, so wherever I see even a hint of color, I elaborate on it. Because the morning sun is rising and both the colors and the light patterns are shifting, I quickly take note of what colors are there and charge paint into wet areas using cobalt violet, raw sienna, cerulean blue, and burnt sienna where appropriate.

3 Next I deepen the shadows on the building using glazes of cobalt violet, and I suggest some of the stones on the stairs and the vegetation on the hill with burnt sienna and a little ultramarine blue; then I go over those brushmarks with clear water to soften them.

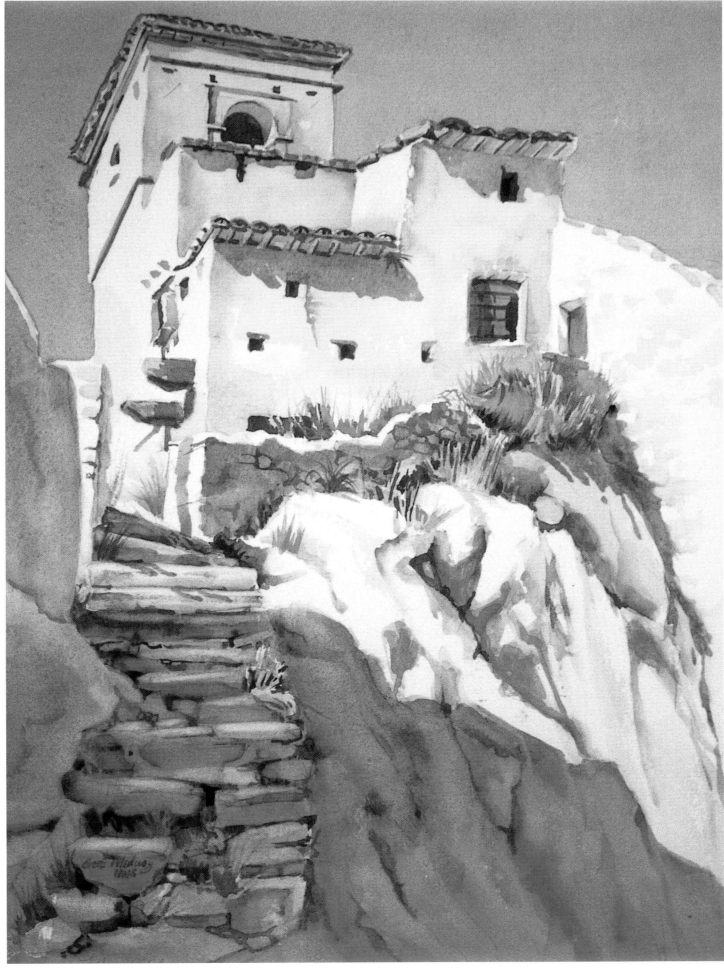

4 In this final step, I apply ultramarine blue, grayed slightly with burnt sienna, on the large shadows (over the steps and the rocky hillside) and to strengthen the colors as needed. The best time to paint outdoors is early morning or late afternoon because the natural light is best then. Plan ahead: You could even sketch the day before, although I did not with this painting. Then you can paint quickly and with confidence.

LIGHT SHADOW

For the light shadows on the house, I apply cobalt violet over a pale wash of burnt sienna.

MEDIUM SHADOW

For the darker house shadows, I use ultramarine blue with touches of burnt sienna.

DARK SHADOW

For the darkest areas, I accent a few of the underlying shadow colors with an additional stroke or two of cobalt violet.

Walter Foster Art Instruction Program

THREE EASY STEPS TO LEARNING ART

Beginner's Guides are specially written to encourage and motivate aspiring artists. This series introduces the various painting and drawing media—acrylic, oil, pastel, pencil, and watercolor—making it the perfect starting point for beginners. Book One introduces the medium, showing some of its diverse possibilities through beautifully rendered examples and simple explanations, and Book Two instructs with a set of engaging art lessons that follow an easy step-by-step approach.

How to Draw and Paint titles contain progressive visual demonstrations, expert advice, and simple written explanations that assist novice artists through the next stages of learning. In this series, professional artists tap into their experience to walk the reader through the artistic process step by step, from preparation work and preliminary sketches to special techniques and final details. Organized by medium, these books provide insight into an array of subjects.

Artist's Library titles offer both beginning and advanced artists the opportunity to expand their creativity, conquer technical obstacles, and explore new media. Written and illustrated by professional artists, the books in this series are ideal for anyone aspiring to reach a new level of expertise. They'll serve as useful tools that artists of all skill levels can refer to again and again.

Walter Foster products are available at art and craft stores everywhere.

For a full list of Walter Foster's titles, visit our website at www.walterfoster.com or send $5 for a catalog and a $5-off coupon.

WALTER FOSTER PUBLISHING, INC.
3 Wrigley, Suite A
Irvine, California 92618
Main Line 949/380-7510
Toll Free 800/426-0099

www.walterfoster.com